SHELLS FROM THE SEA
A Coloring Adventure

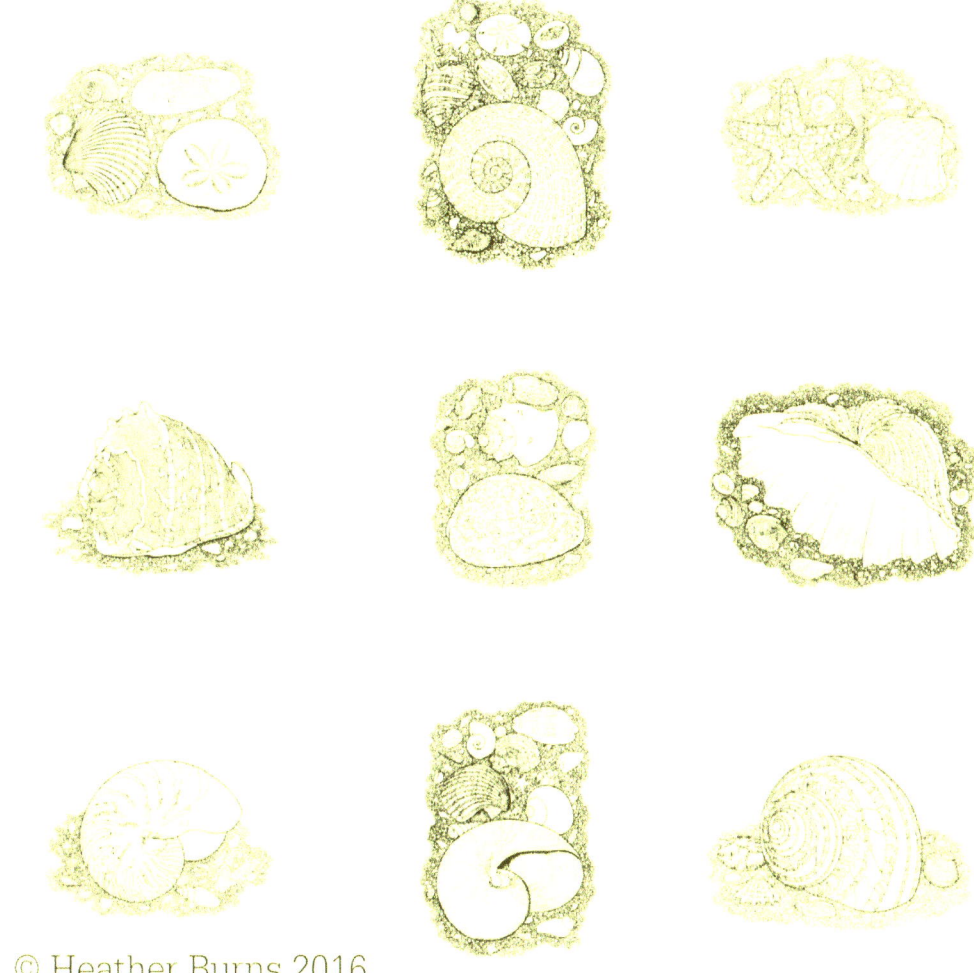

© Heather Burns 2016

This Coloring Book Belongs to

© Heather Burns, 2016, All Rights Reserved

Shells From the Sea
Published in Wexford, Ireland, 2016.

All images in this coloring book are copyrighted by Heather Burns, all rights reserved. Absolutely no commercial use is allowed. You cannot use the images to post to a site on the internet or on a product for sale. To do so constitutes copyright infringement. Even if you color them, you cannot then use them commercially. Also please do not remove my copyright information printed on each page. Thank you for your understanding.

All the shells in this book are hand drawn from my own shell collection. I collected them from beaches all over the world. Enjoy!

You can find more of my work in these places:

My State Flowers Coloring Book:

http://state-flowers-usa-coloring.blogspot.com

https://www.createspace.com/5851511

My Swan Photo Book:

https://www.createspace.com/6328378

(I own Aurora Art Supplies)
http://aurora-artsupplies.com

© Heather Burns, 2016

© Heather Burns

© Heather Burns

© Heather Burns

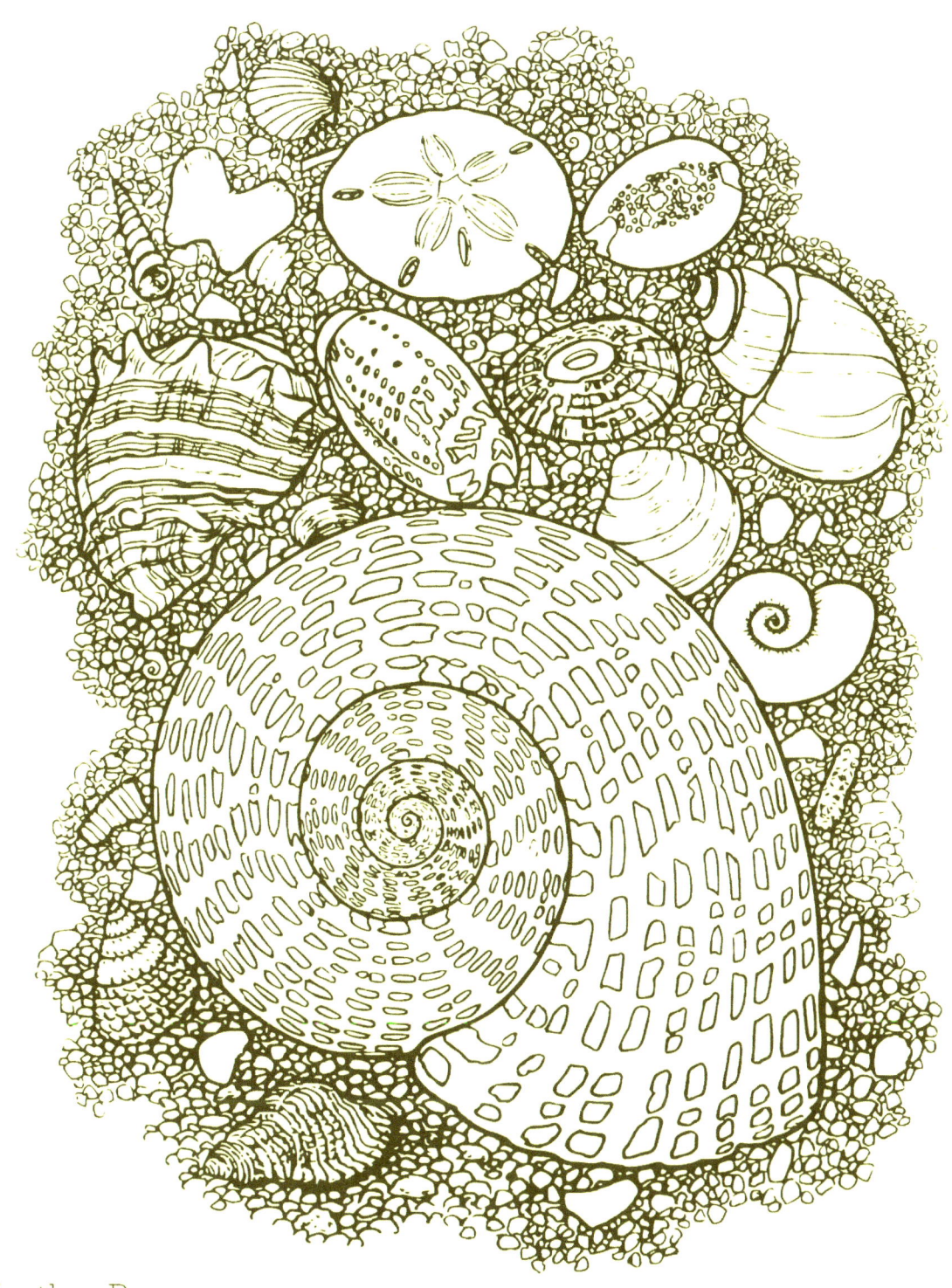

© Heather Burns

© Heather Burns

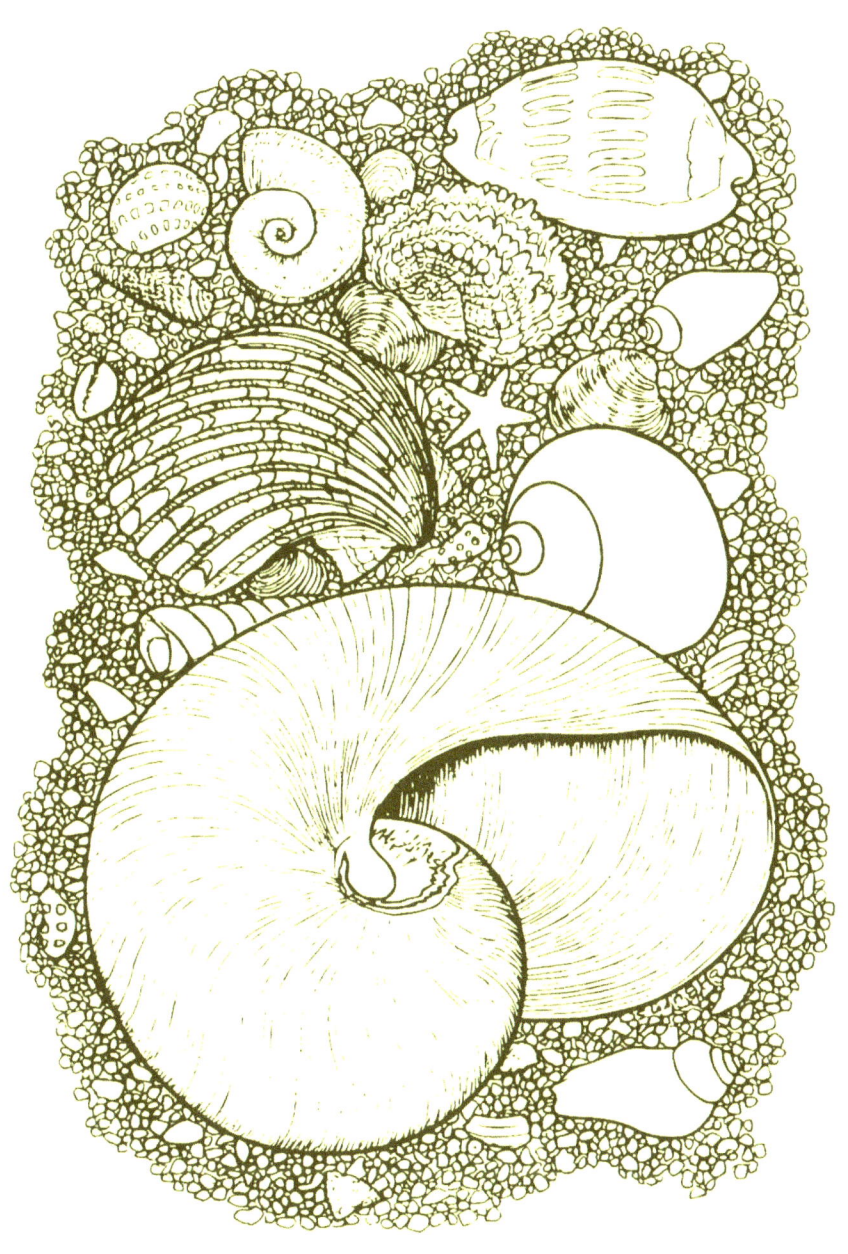

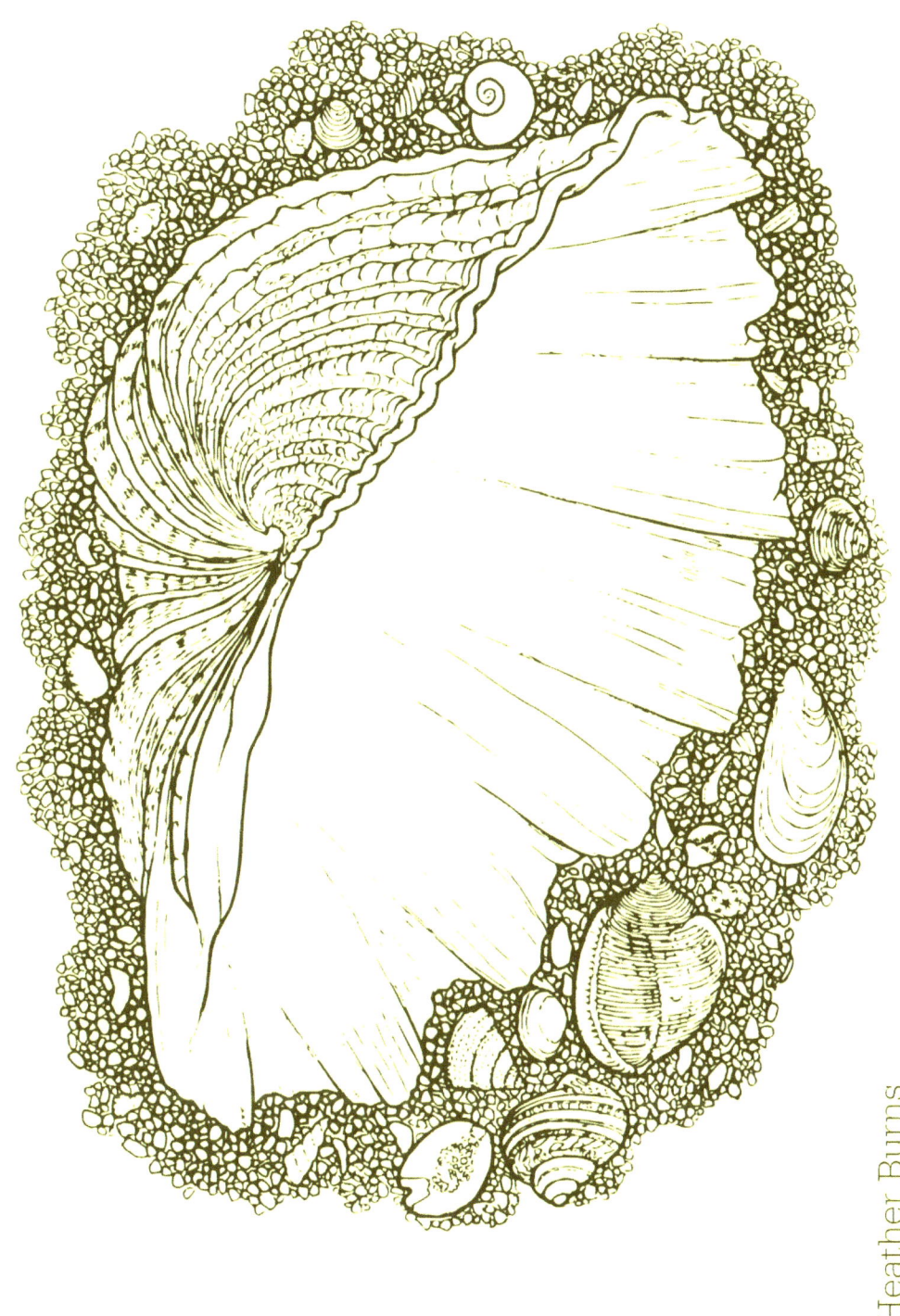

© Heather Burns

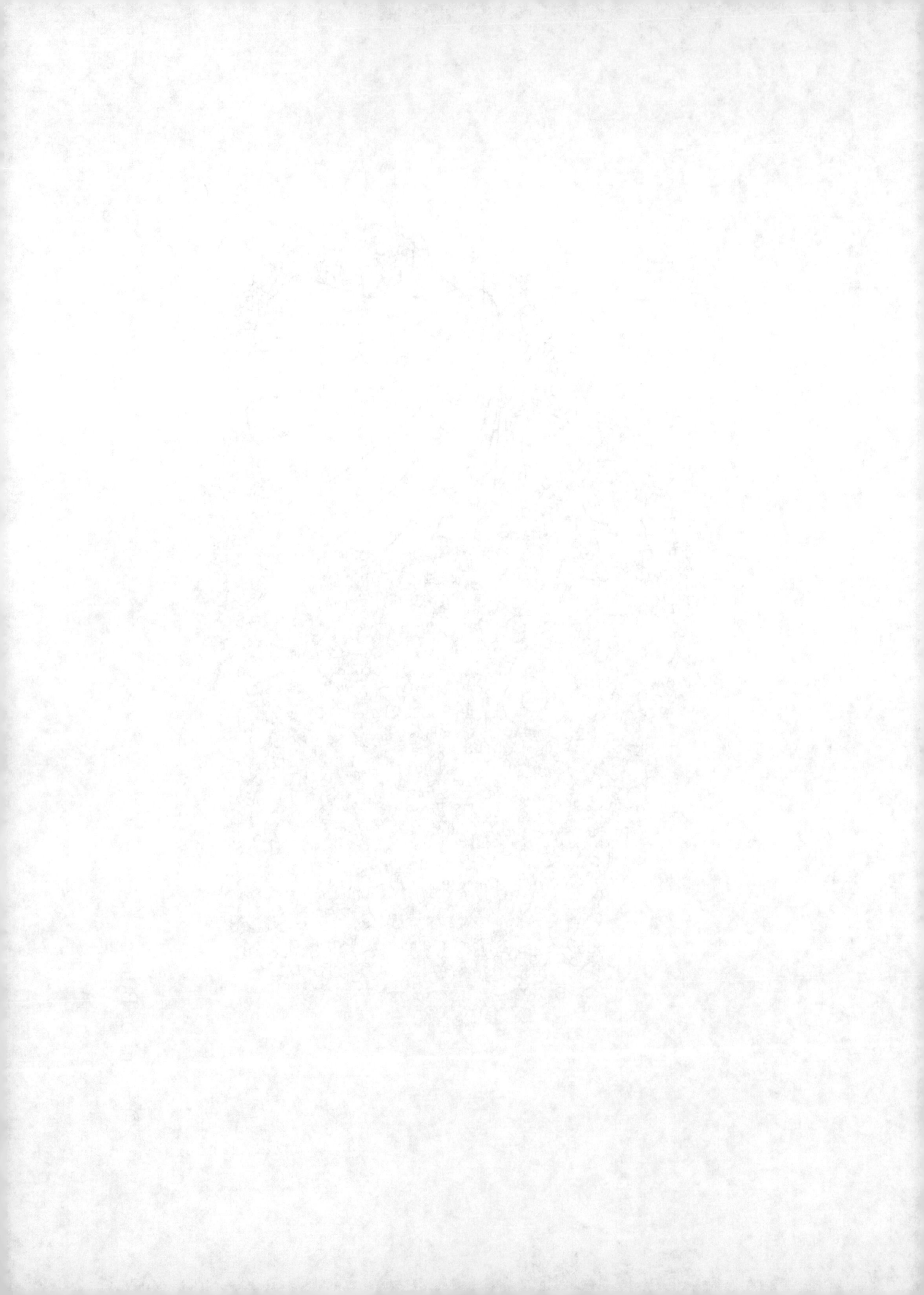

© Heather Burns

© Heather Burns

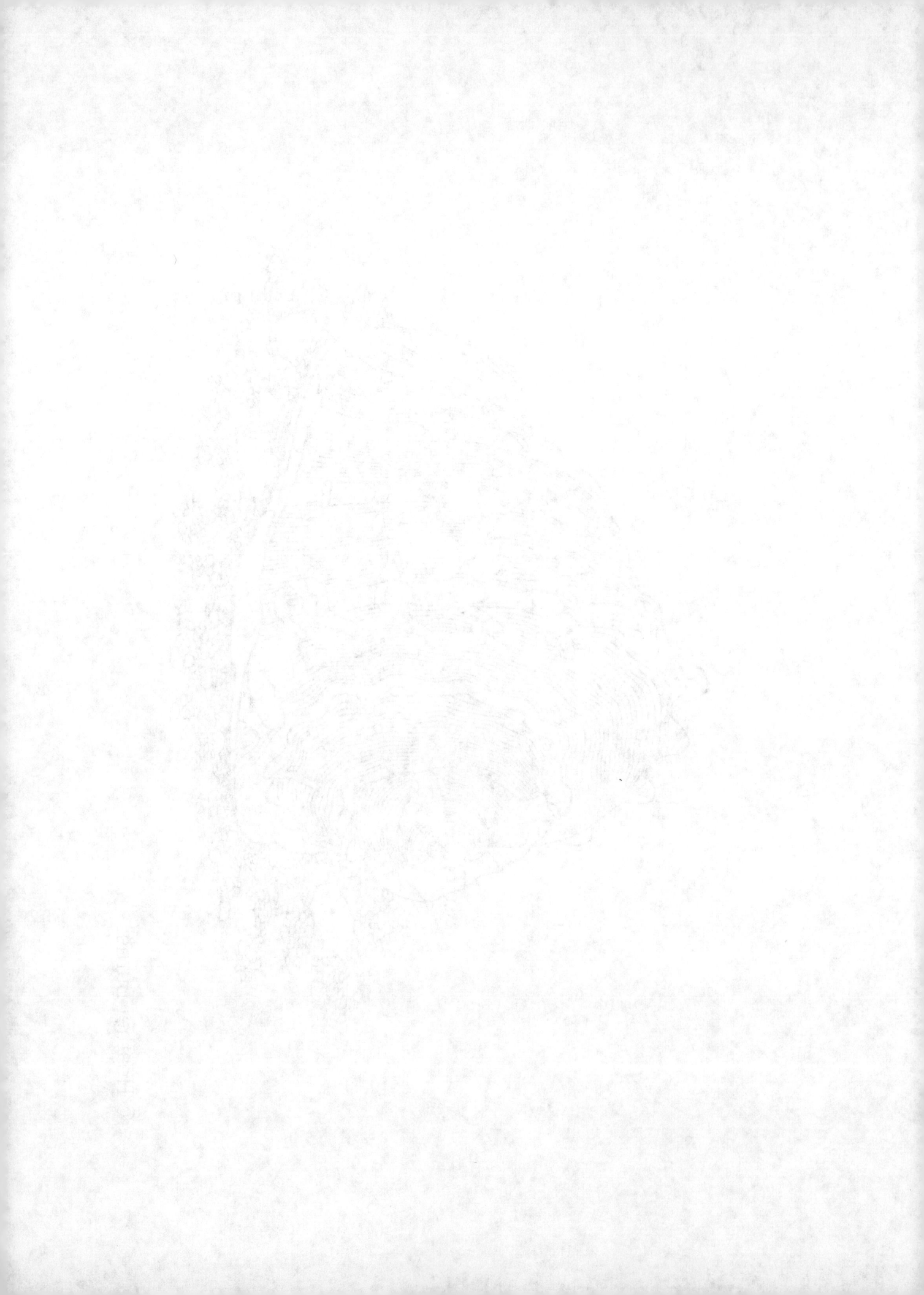

© Heather Burns

© Heather Burns

© Heather Burns

© Heather Burns

© Heather Burns

© Heather Burns

© Heather Burns

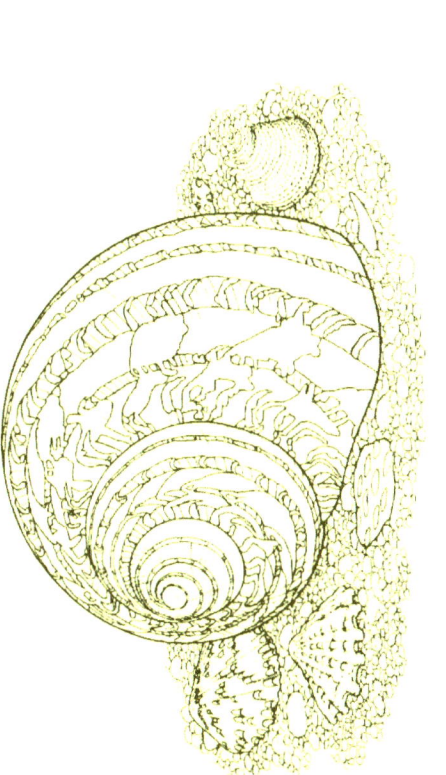

© Heather Burns

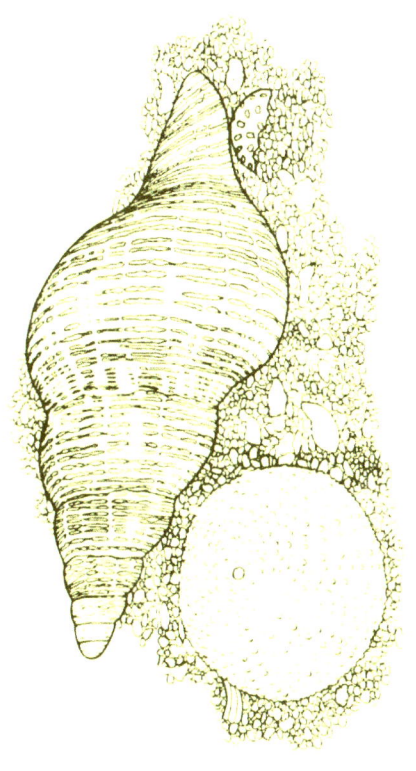

© Heather Burns

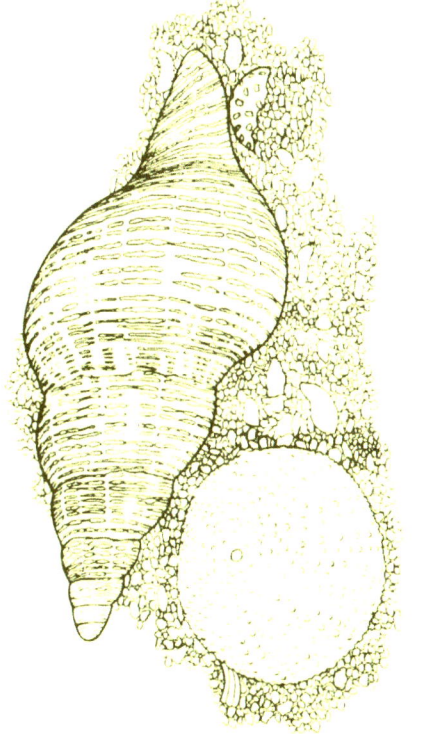

© Heather Burns

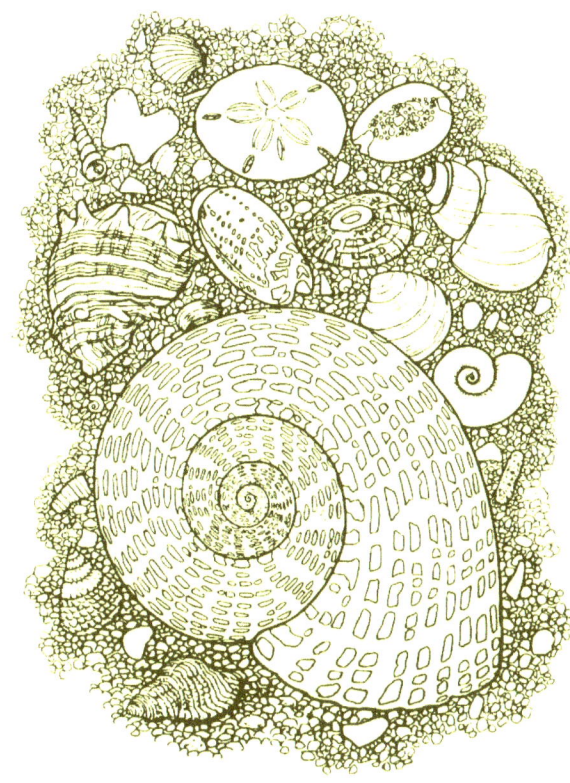
© Heather Burns

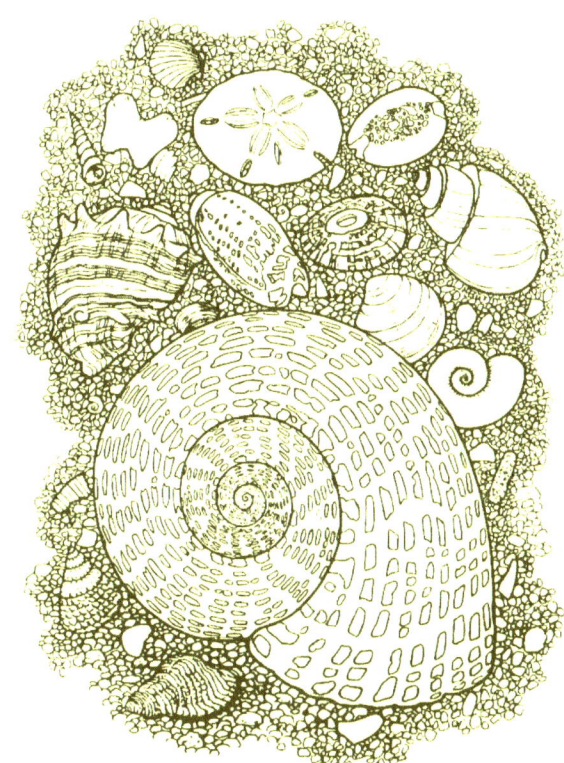
© Heather Burns

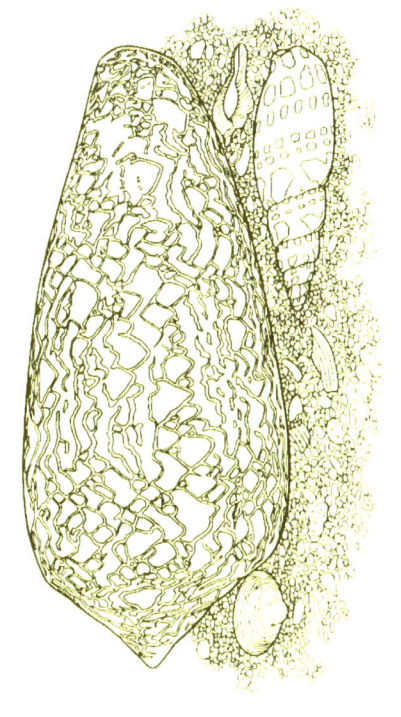

© Heather Burns

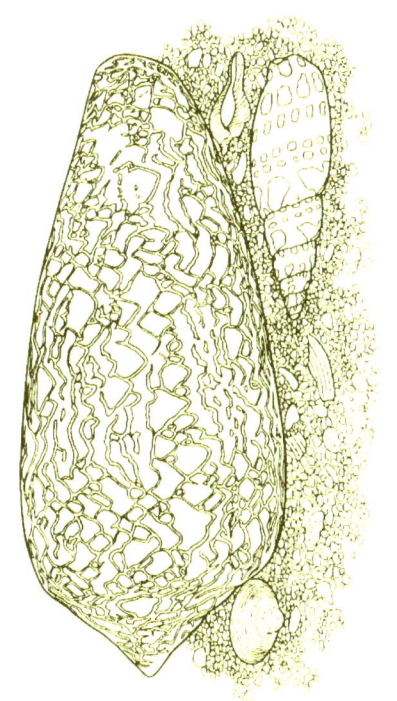

© Heather Burns

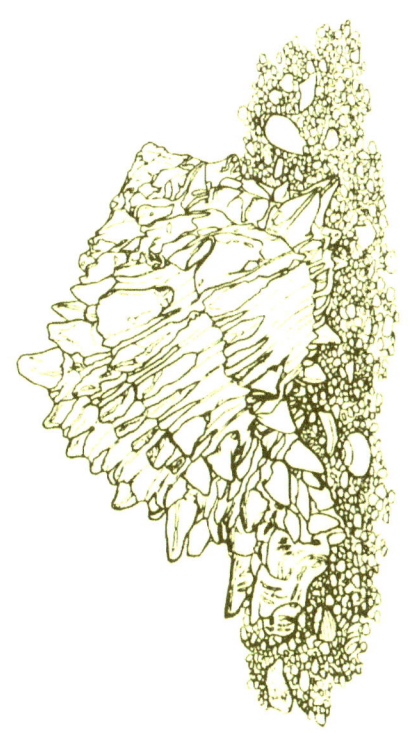
© Heather Burns

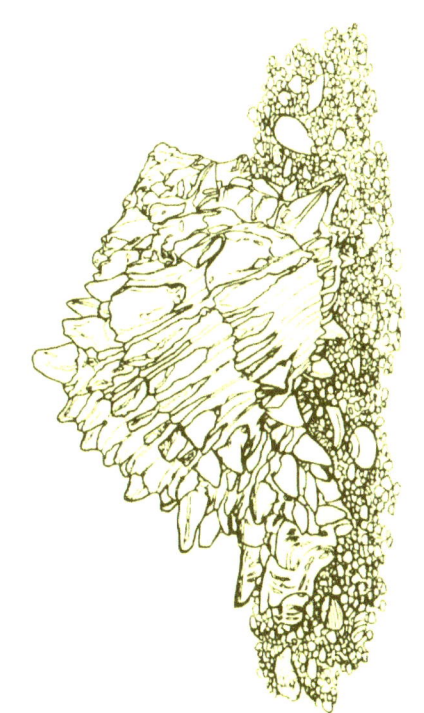
© Heather Burns

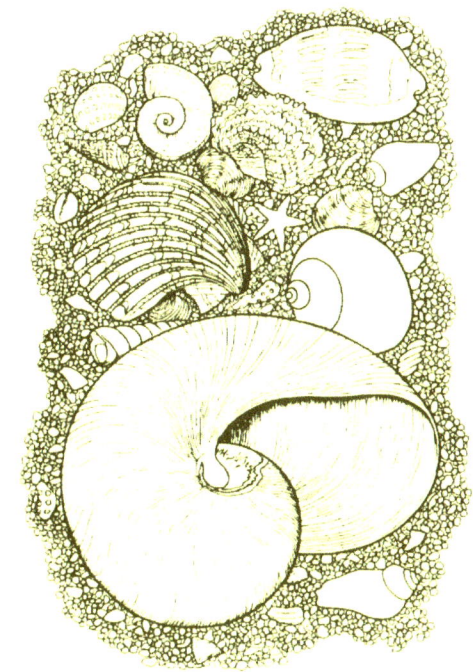

© Heather Burns

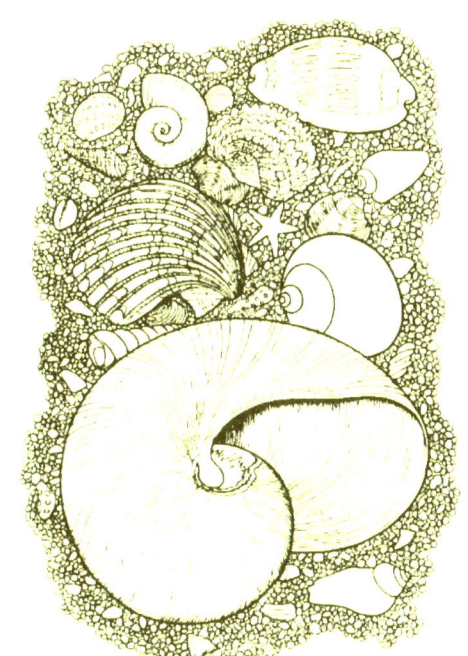

© Heather Burns

© Heather Burns

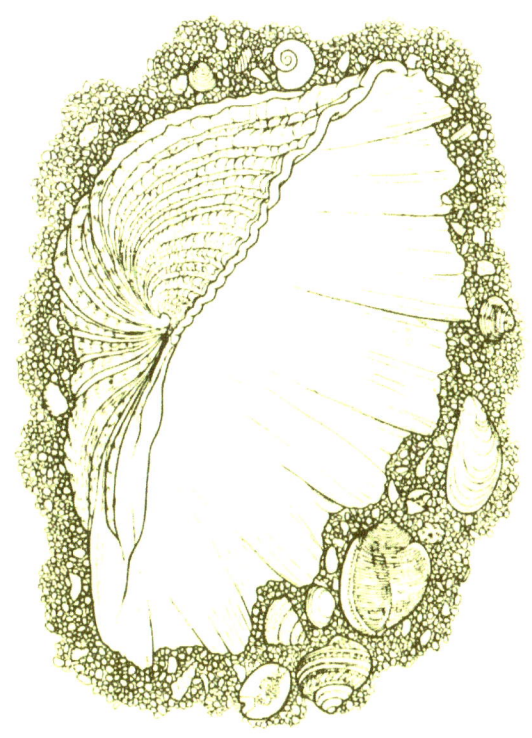

© Heather Burns

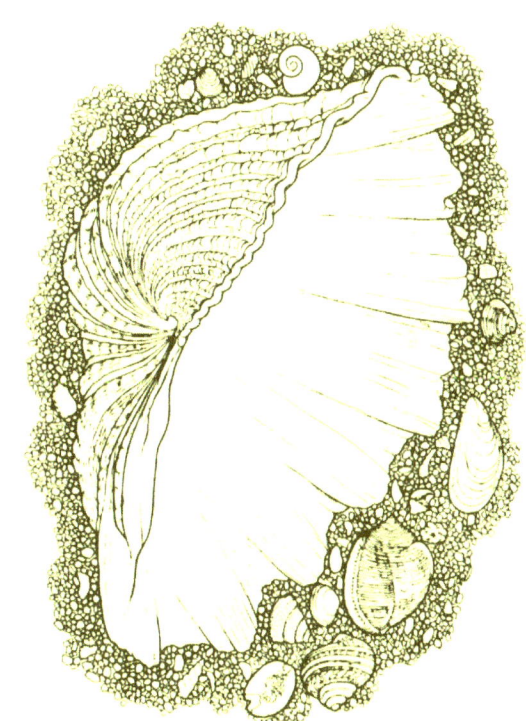

© Heather Burns

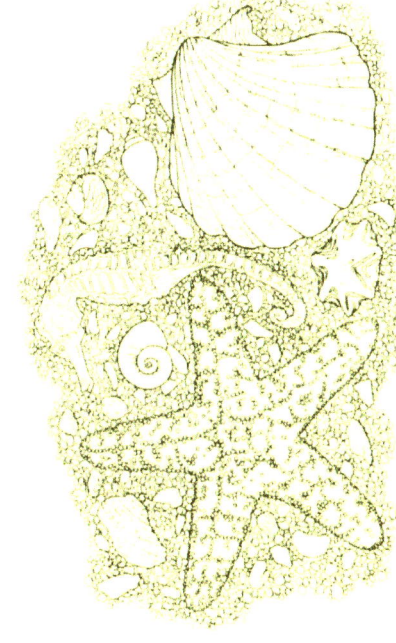

© Heather Burns

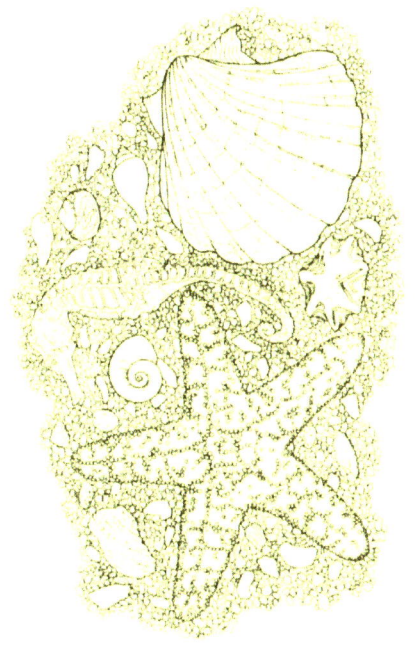

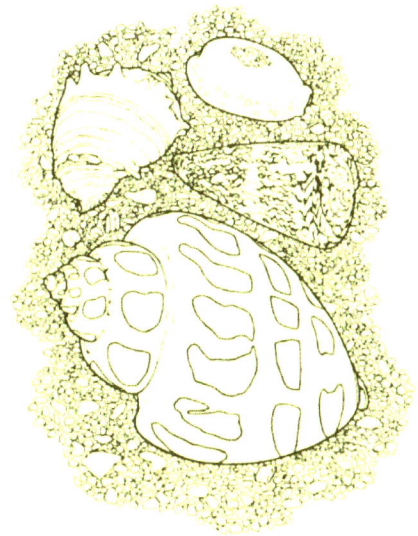

© Heather Burns

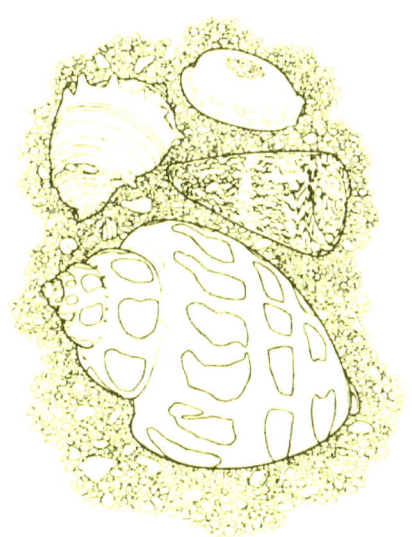

© Heather Burns

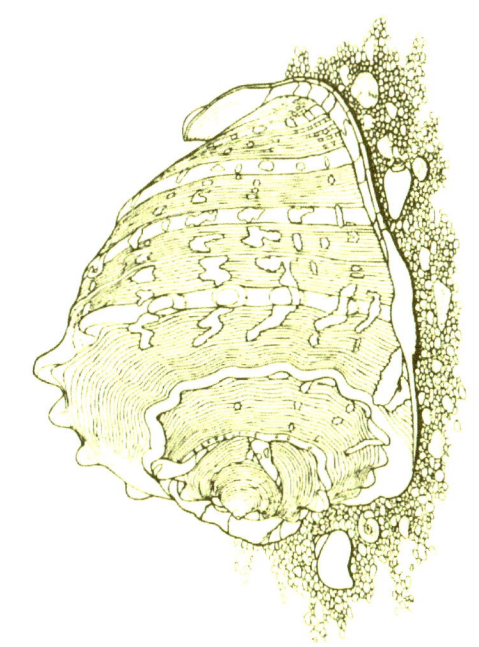

© Heather Burns

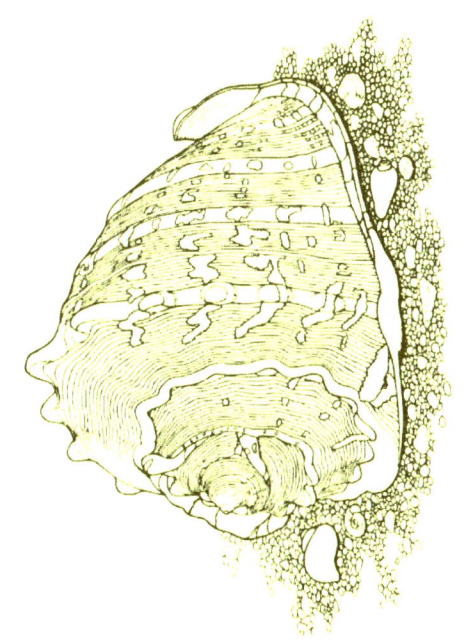

© Heather Burns

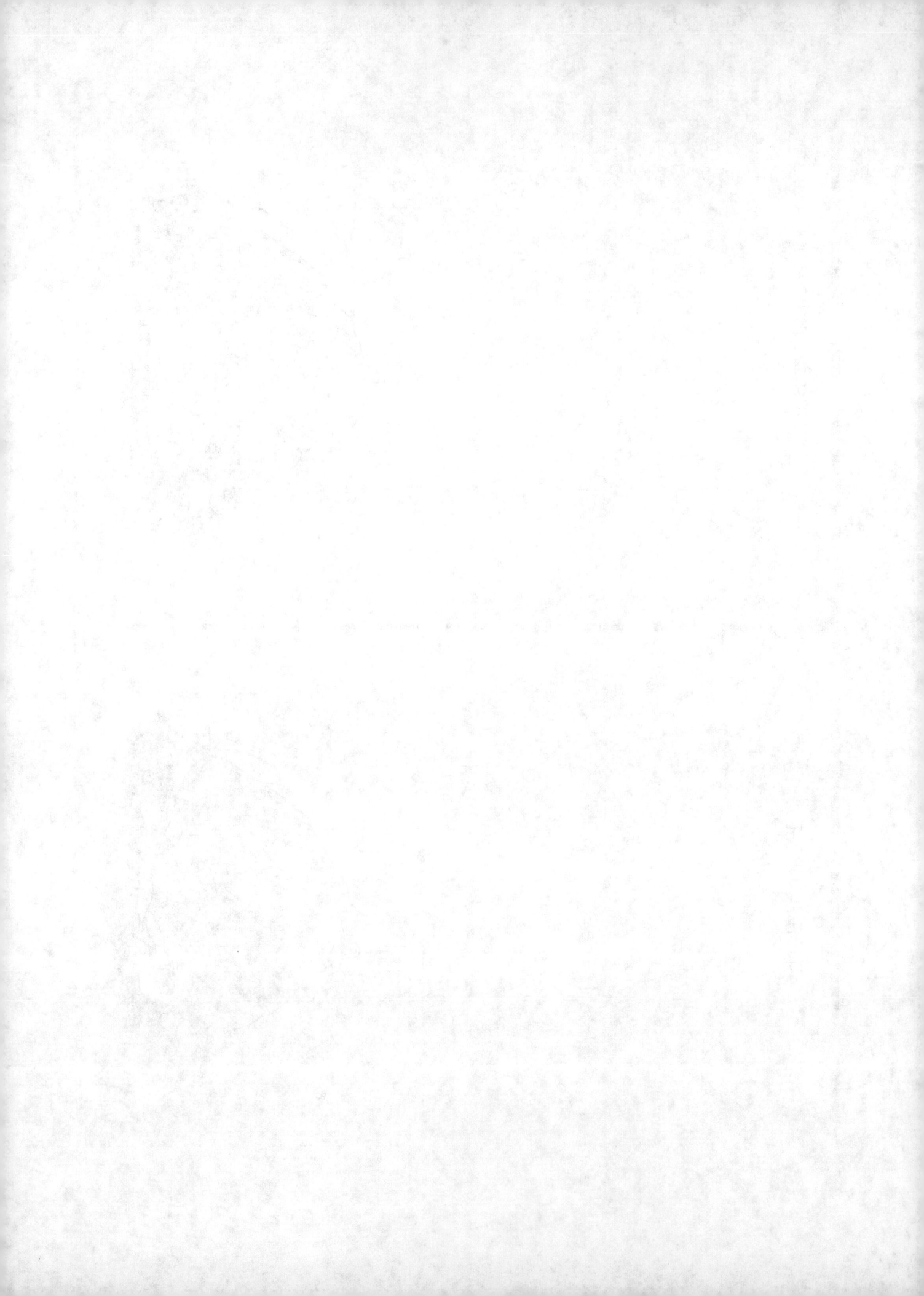

© Heather Burns

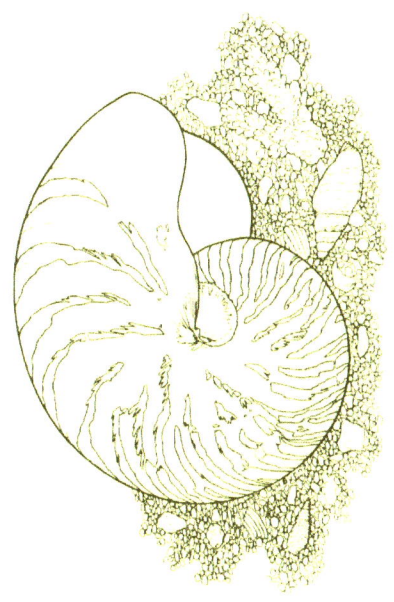

© Heather Burns

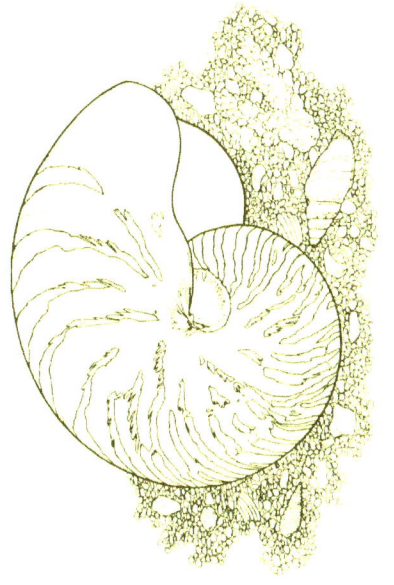

© Heather Burns

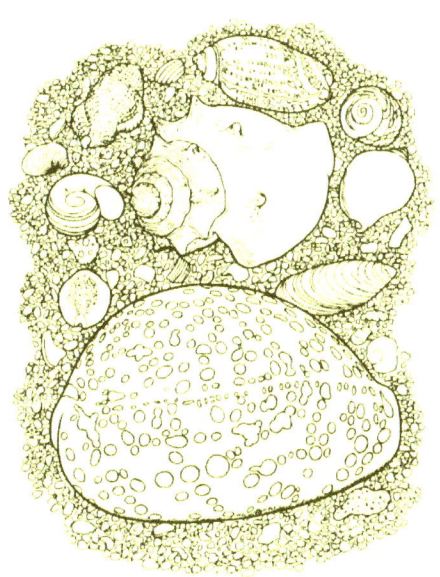

© Heather Burns

© Heather Burns

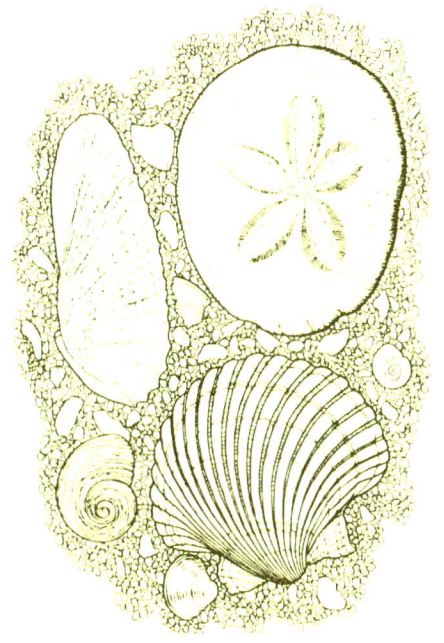

© Heather Burns

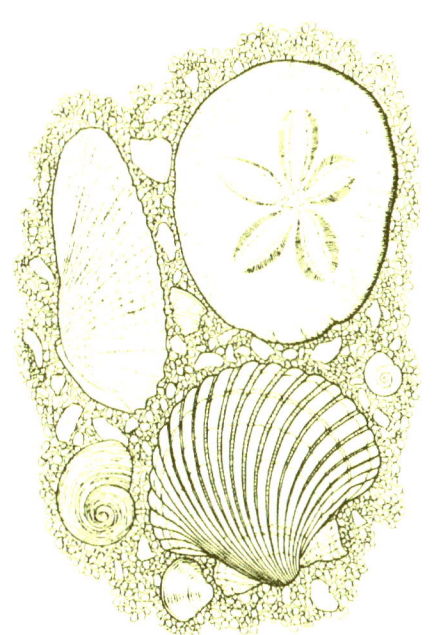

This is a template for envelopes. Cut out the shape, fold the side tabs in, fold up the bottom tab, and tape or glue the three tabs to form an envelope. Insert a card, and seal the envelope with the top tab. You can also use a business type envelope.

www.ingramcontent.com/pod-product-compliance
Lightning Source LLC
Chambersburg PA
CBHW080545190526
45169CB00007B/2641